the CURIOUS Coloring Book

*

Faery Forest

*

Andrea Mina Savar

Step into the forest, leave your worries behind

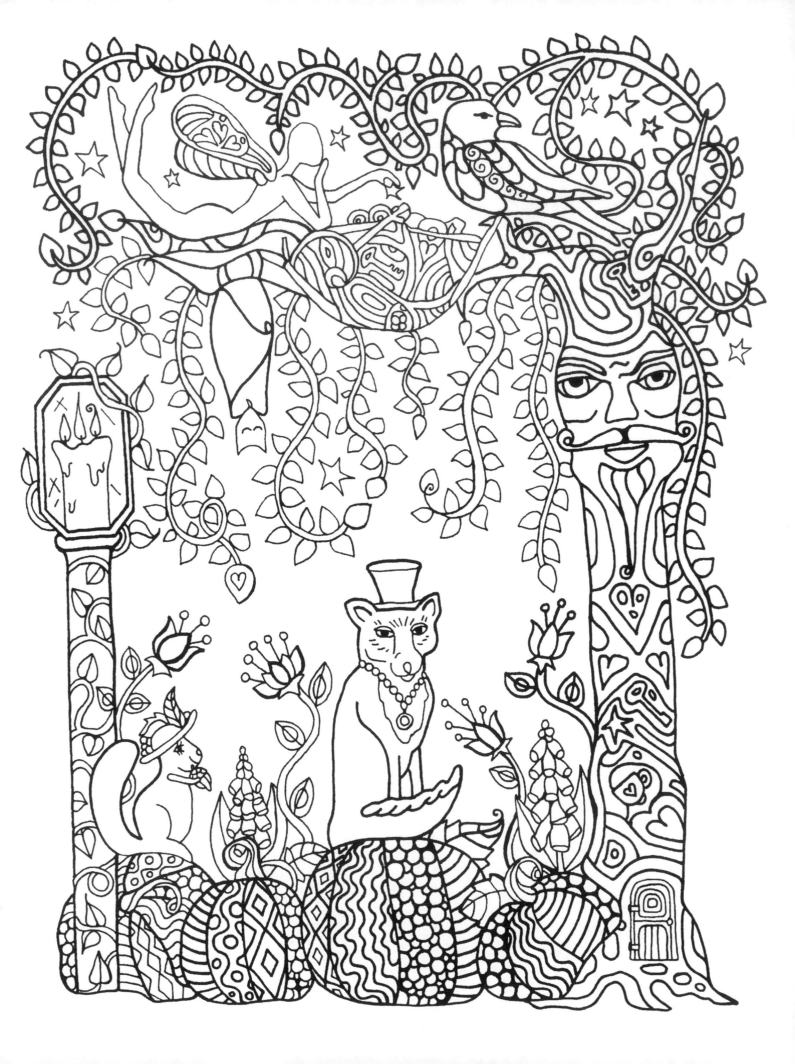

With a compass to guide each dragonfly line.

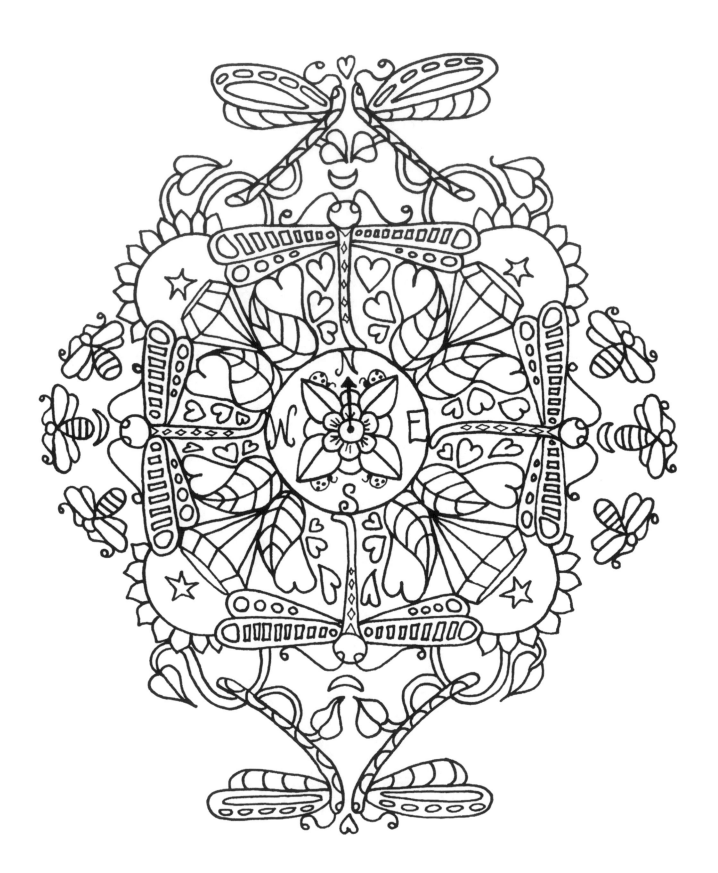

A fortune is hidden at the bottom of a cup

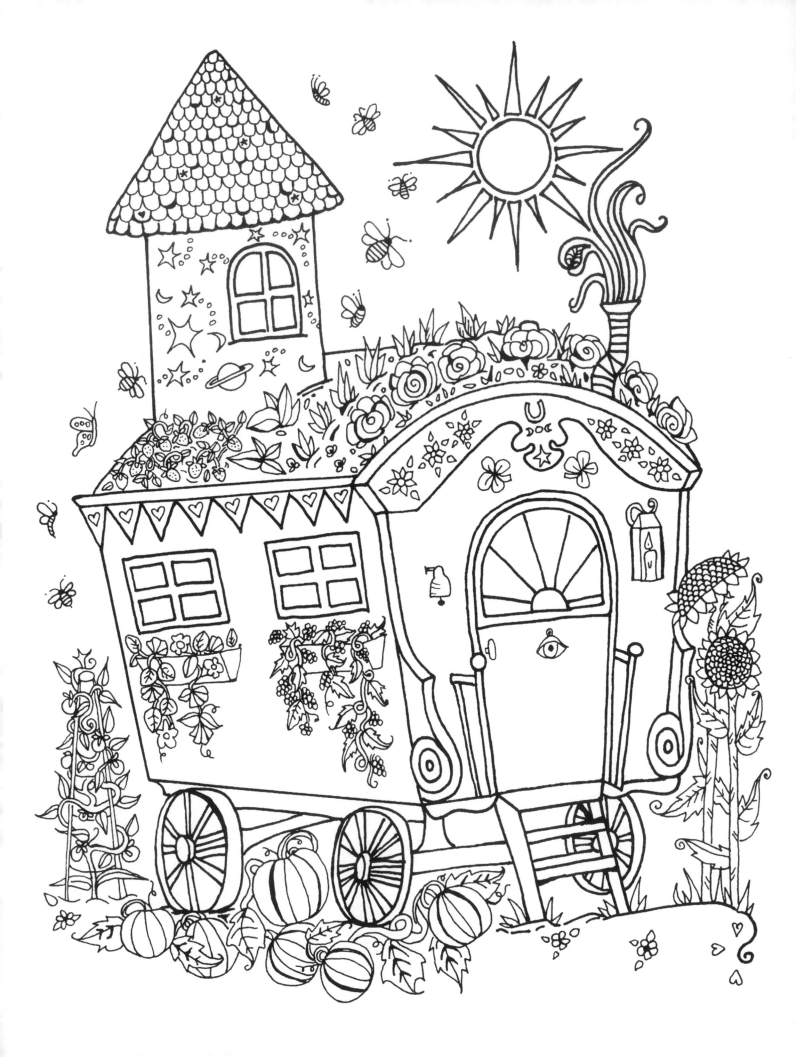

Let the owls lead your journey of abundant good luck.

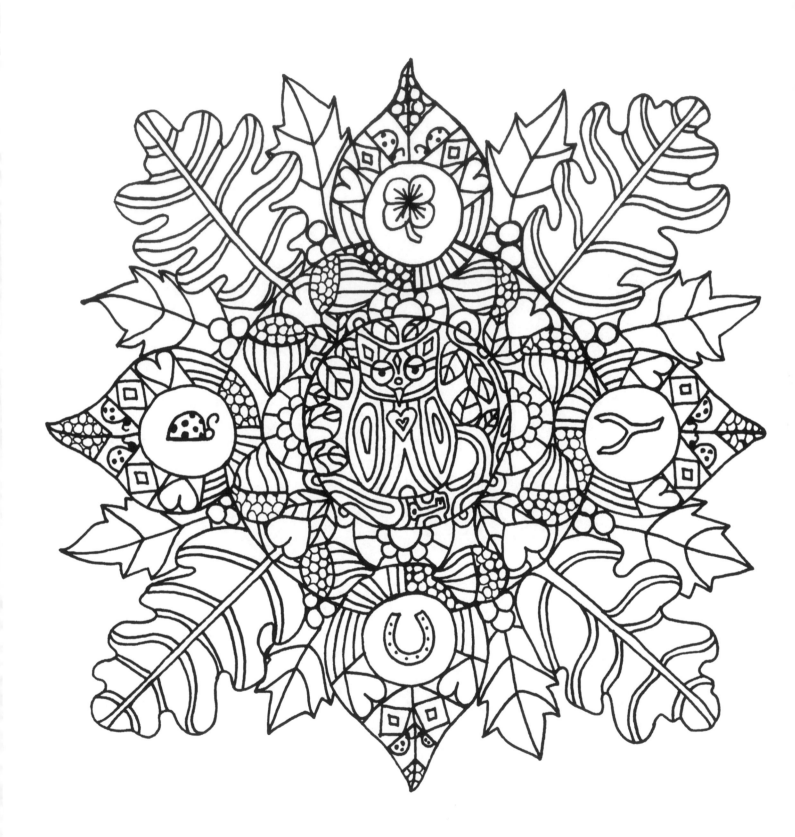

So drift on the leaves as the bats swish aside

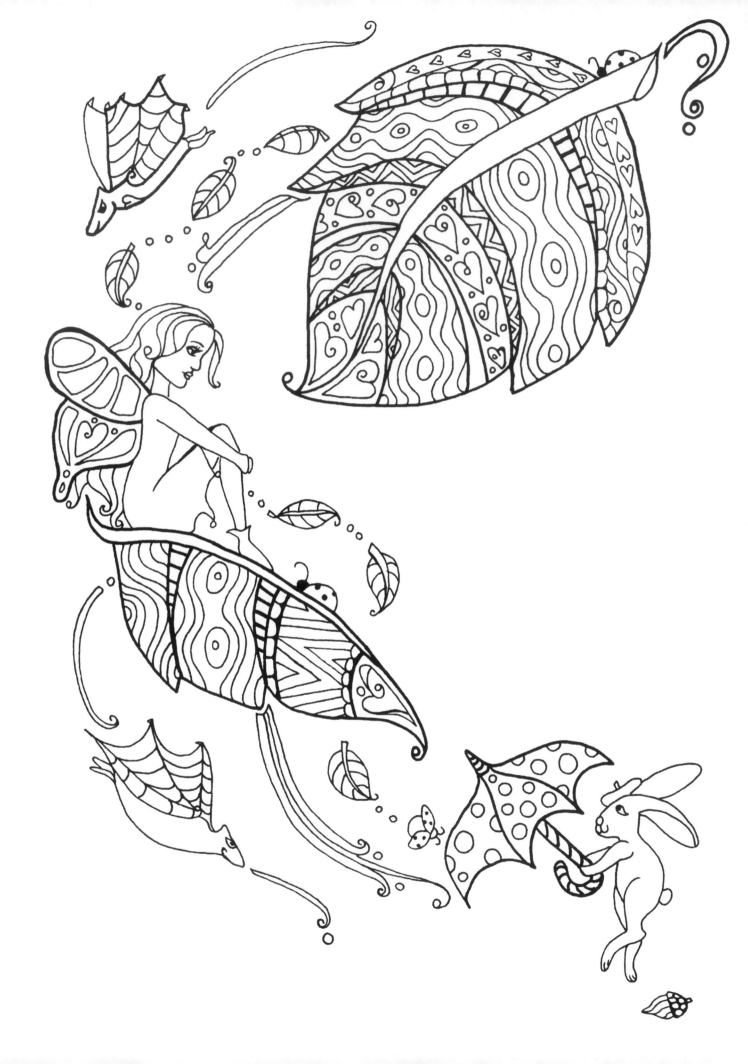

Lost treasures and wishes a dragon might hide.

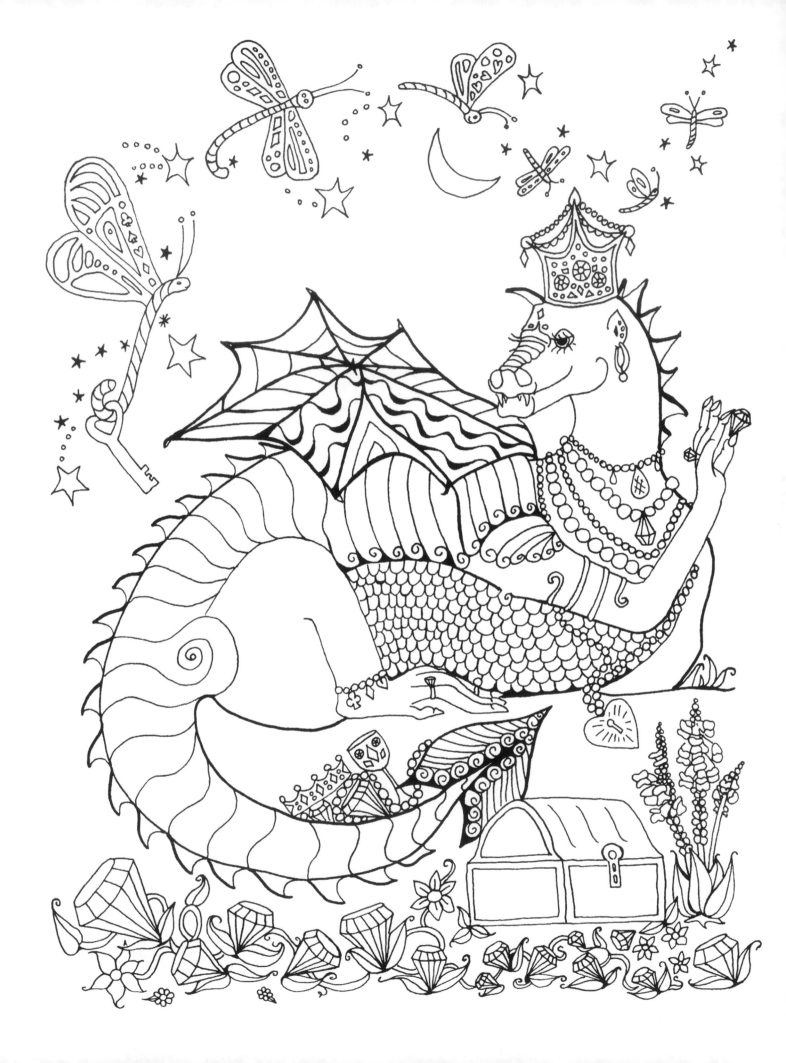

Peek into the trees and under the berries

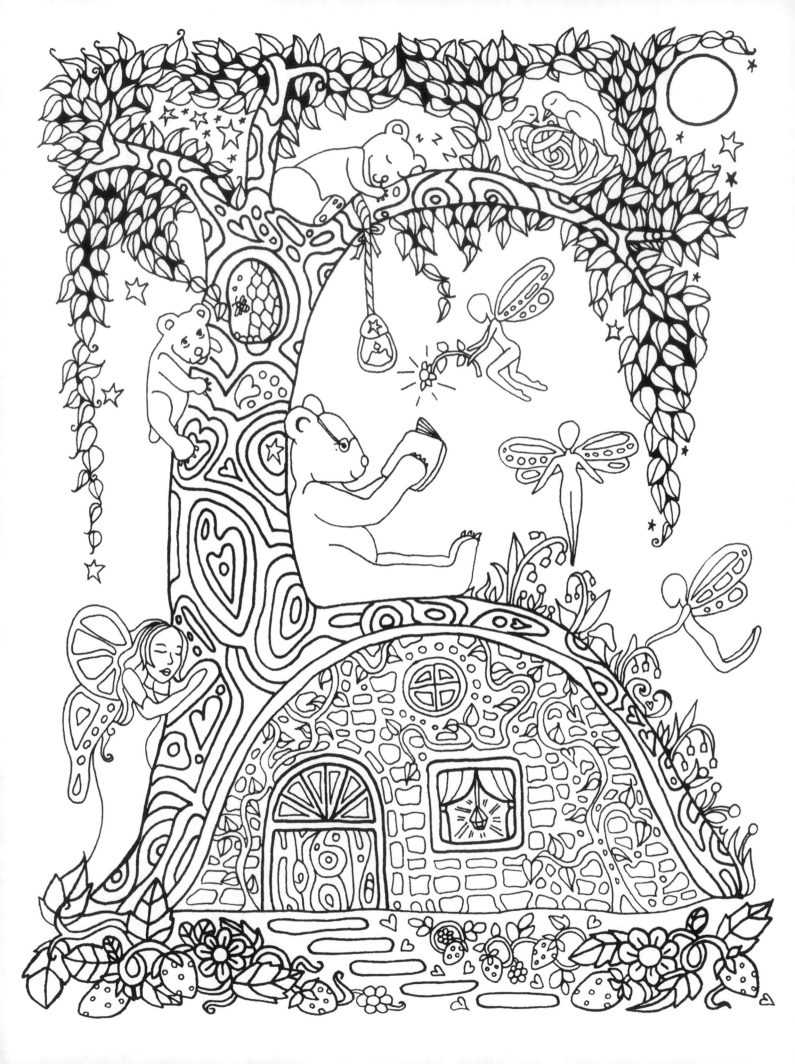

That's where you'll find the wiliest faeries.

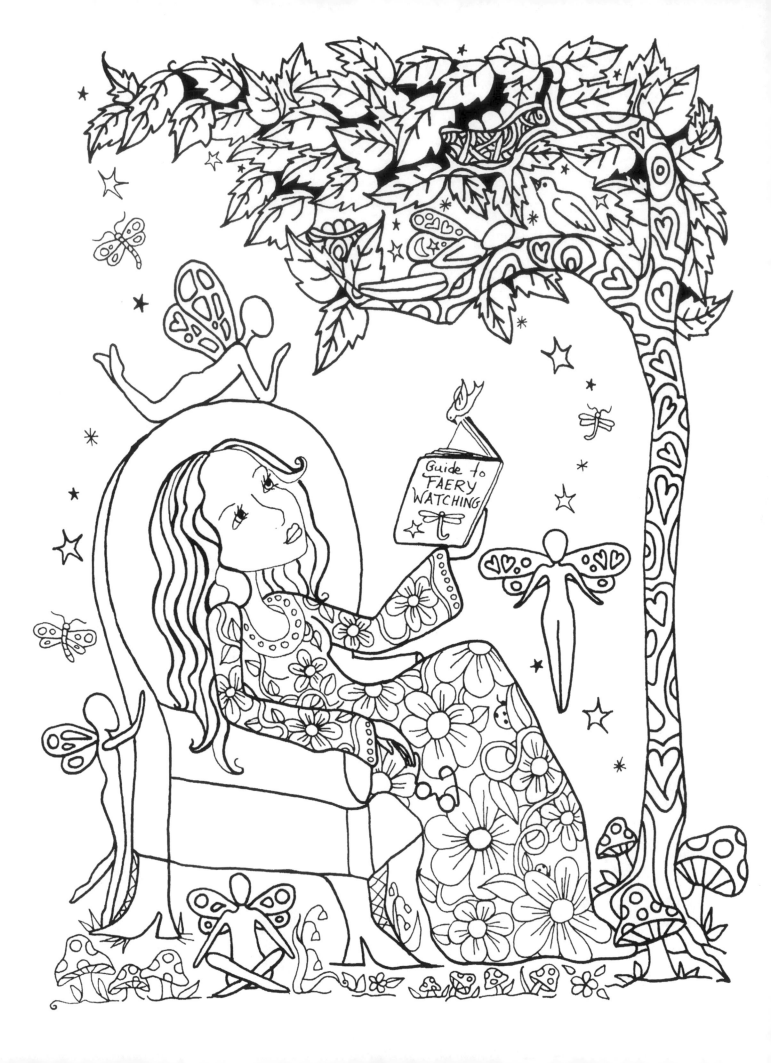

Flora and Fauna have gathered their friends

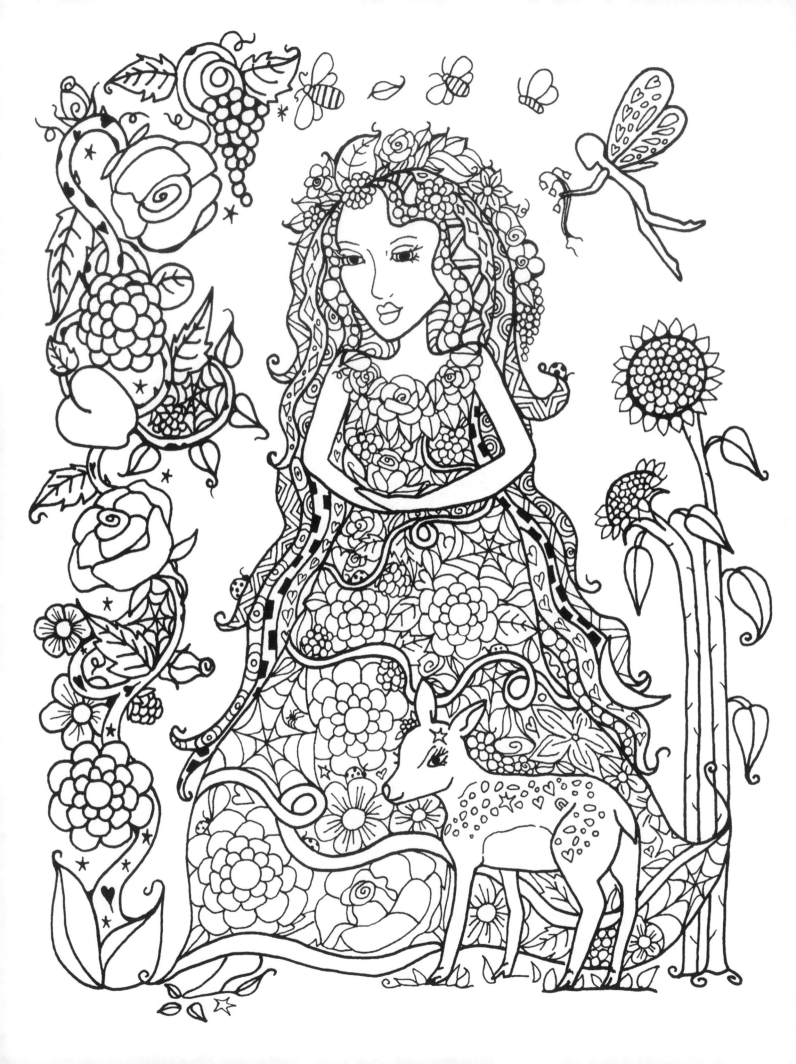

Of wing and root on your path they wend.

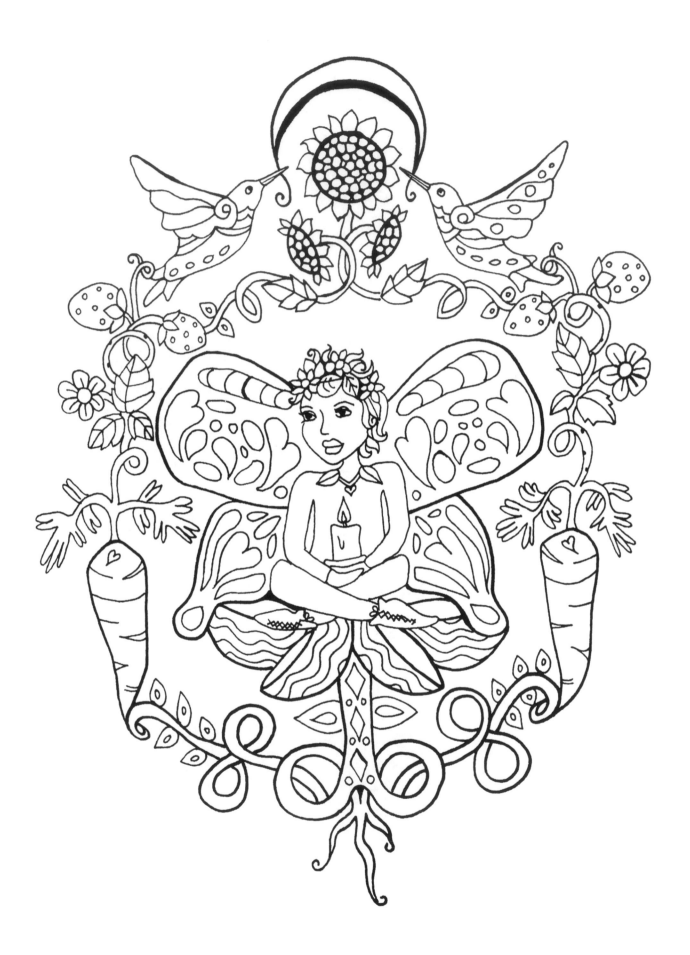

With feathers to offer and lights held high

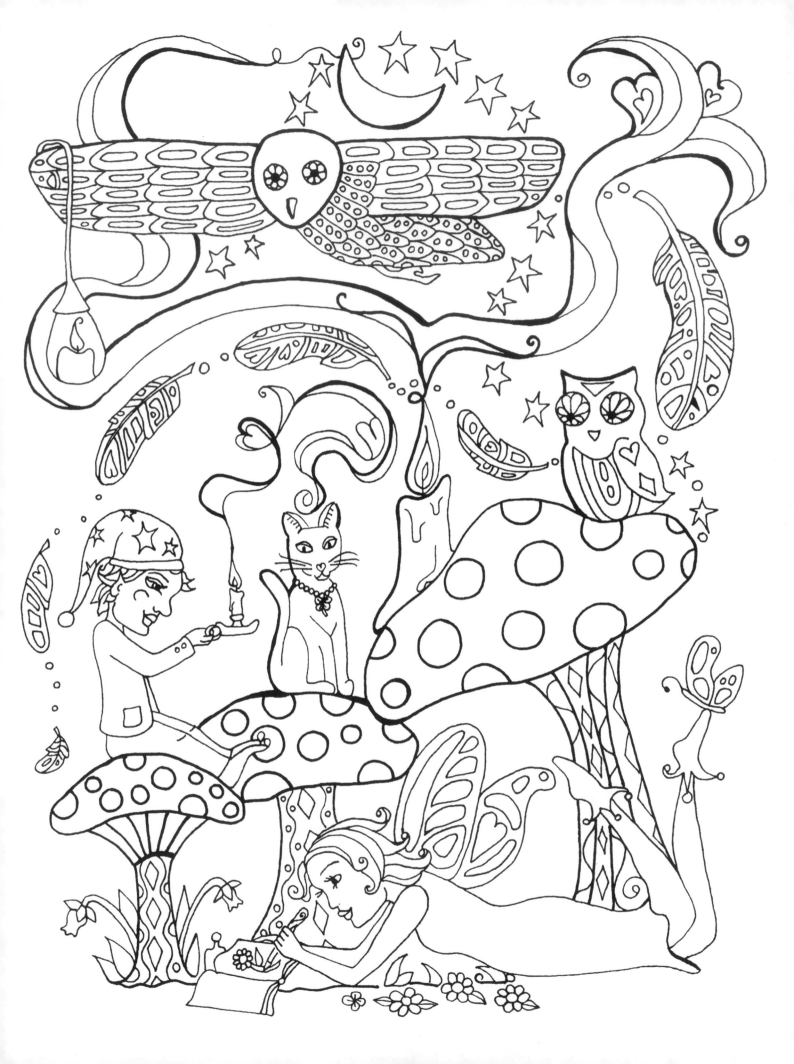

A treehouse for shelter when moonlight is nigh.

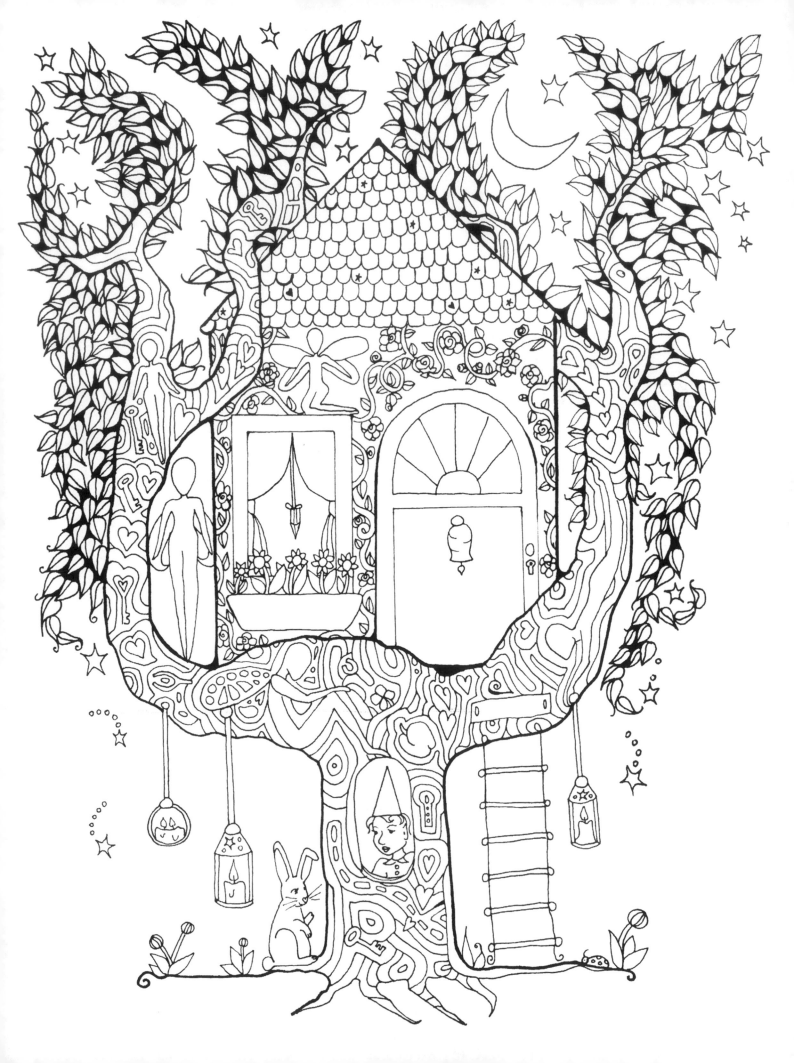

Rest with the bears and share bee dryad dreams

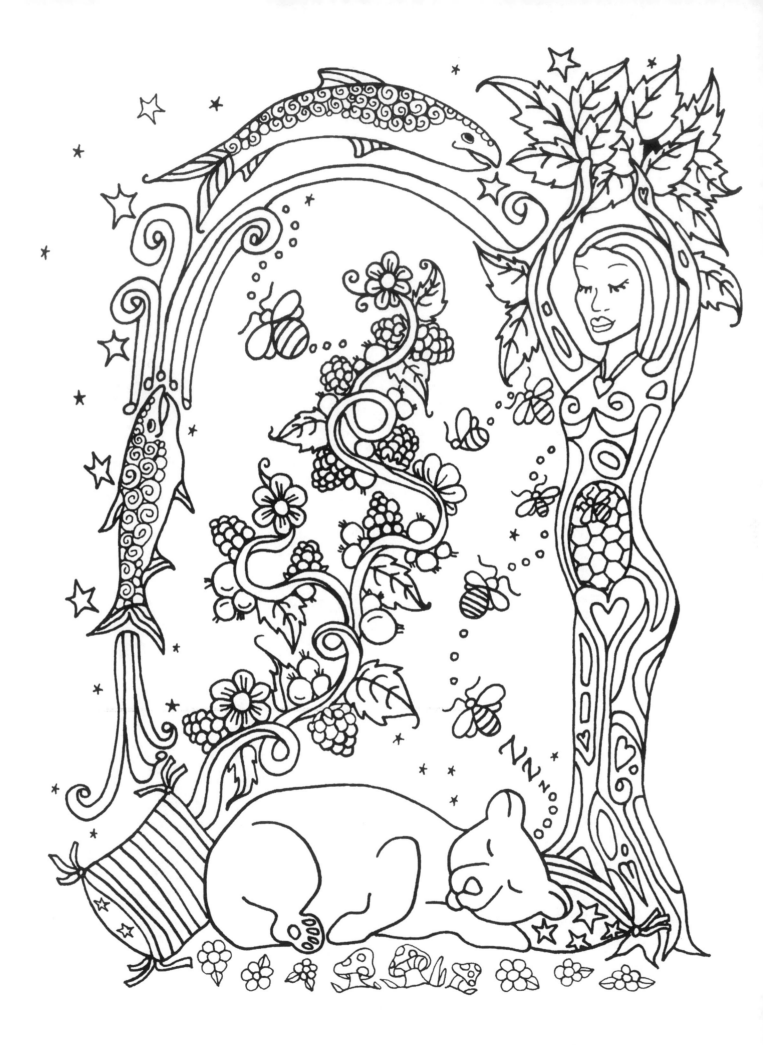

While the Green Man stands watchful of impish night schemes.

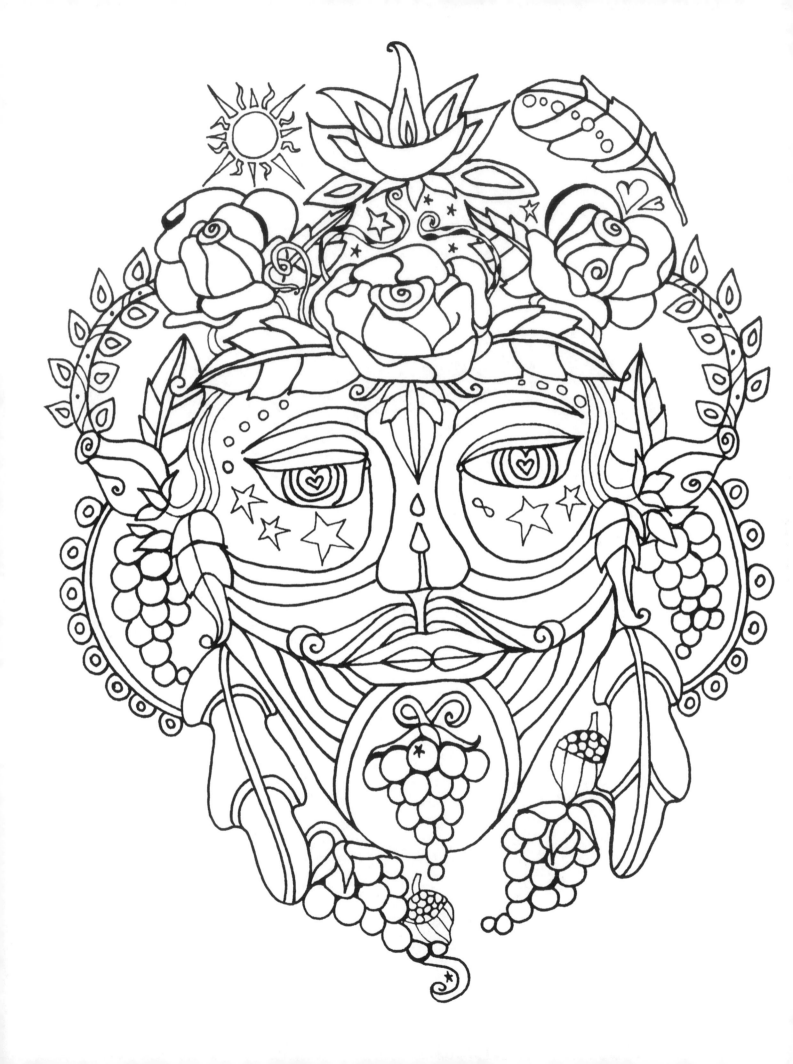

The frog chorus sings to their dragonfly love

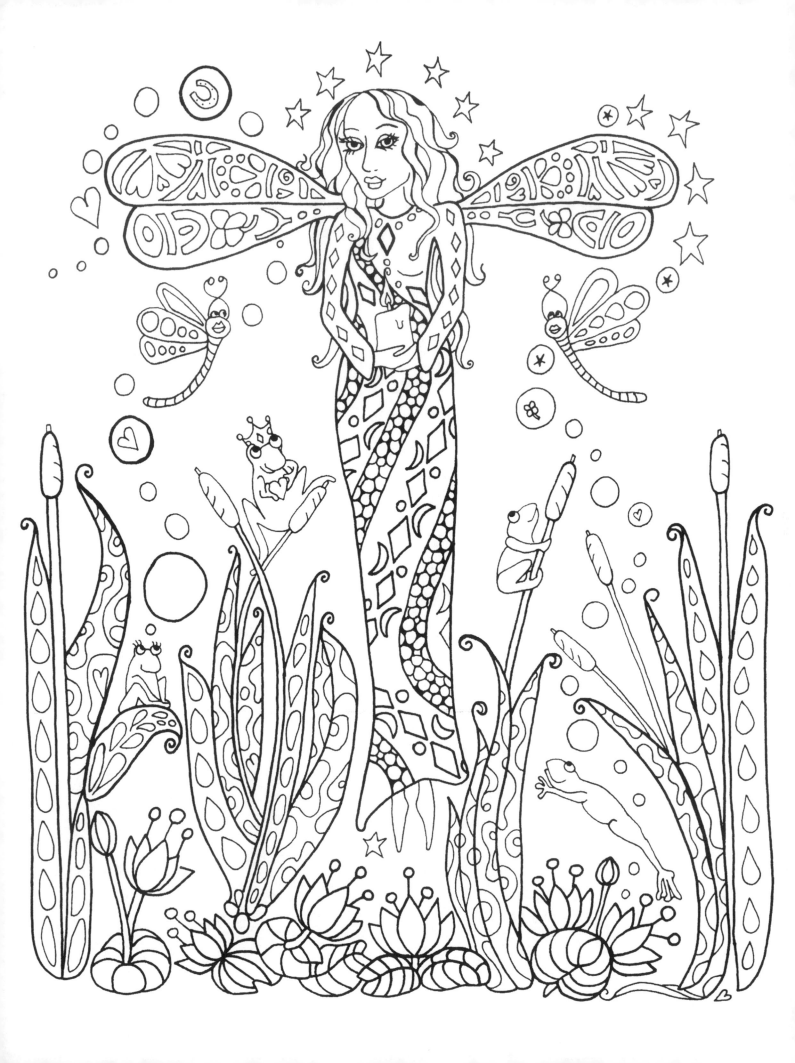

A lullaby whispered from the stars above

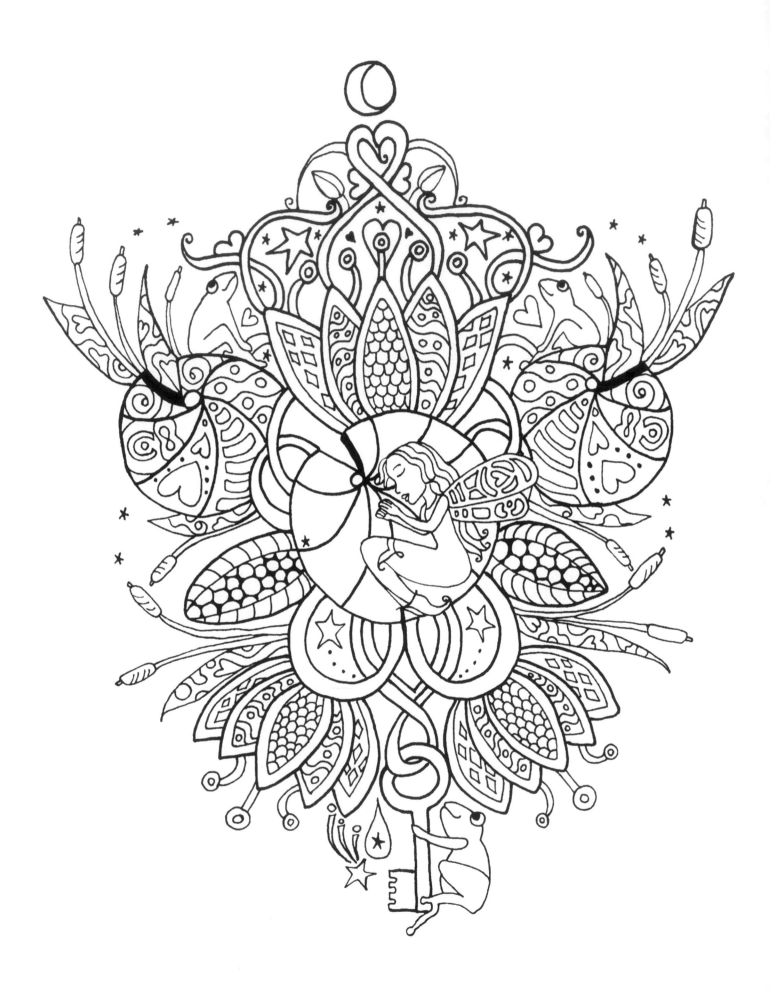

Of diamonds tucked gently in summer rose wild

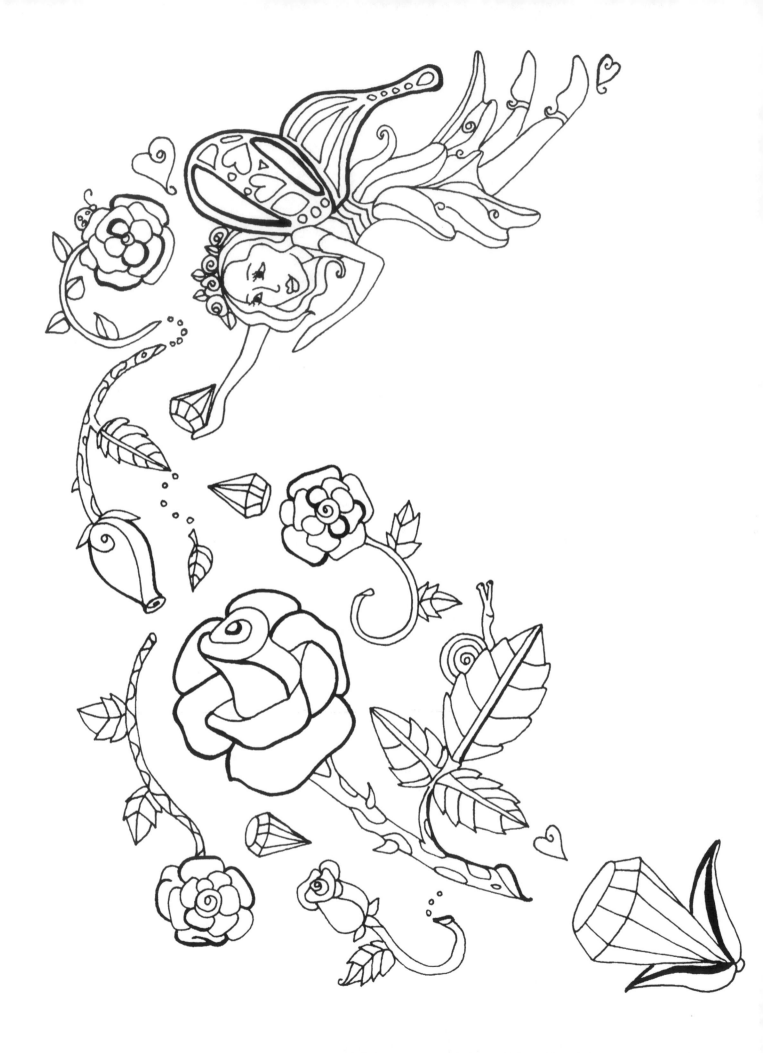

That awaken in Spring to bloom a faery child.

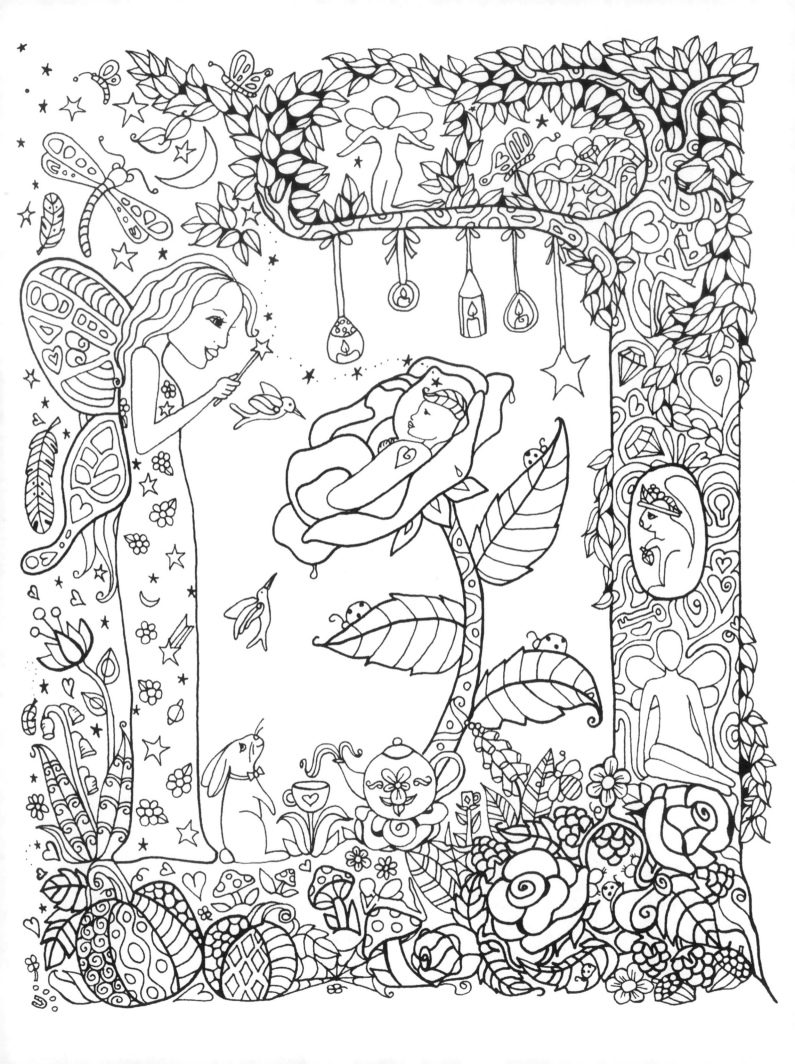

In the Faery Forest, celebration is the key

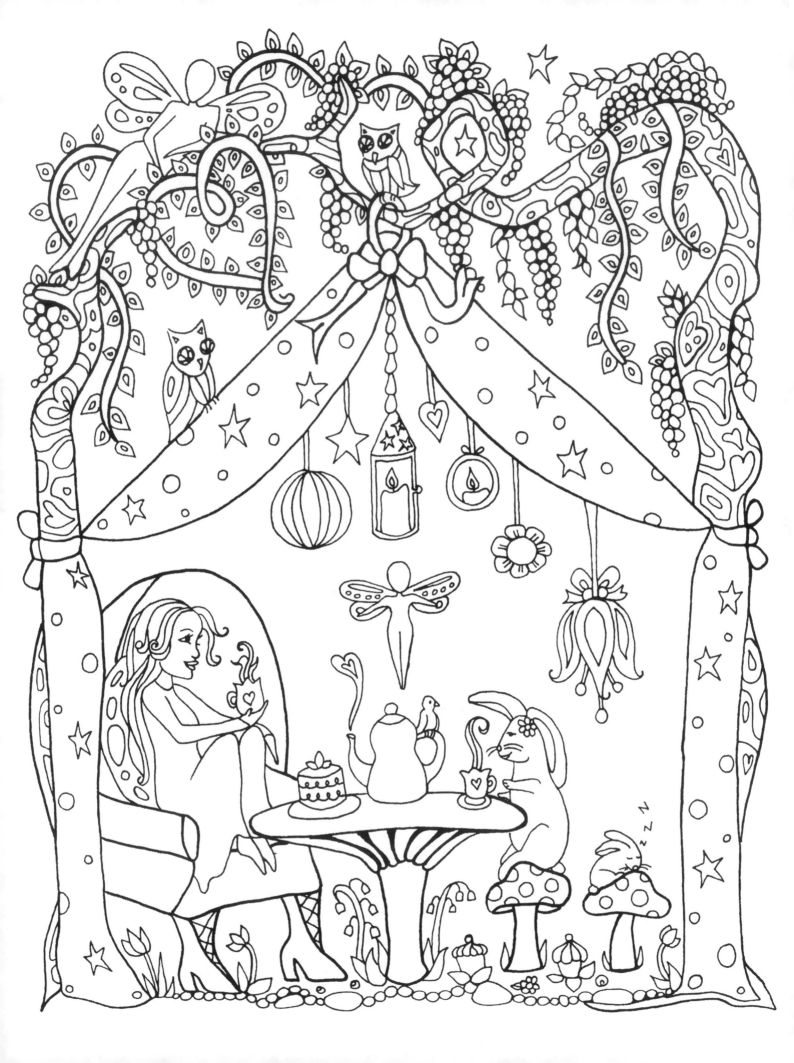

To the lifting of spirits by hummingbird and bee.

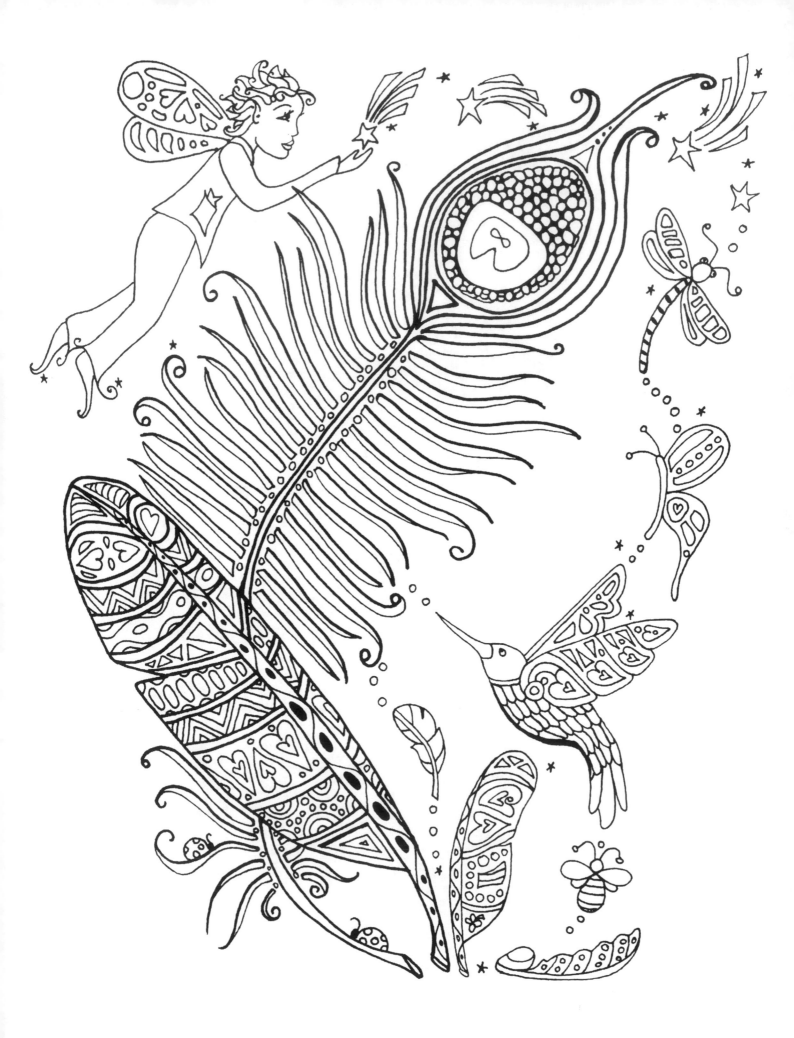

For in the imagination, hope butterflies brew

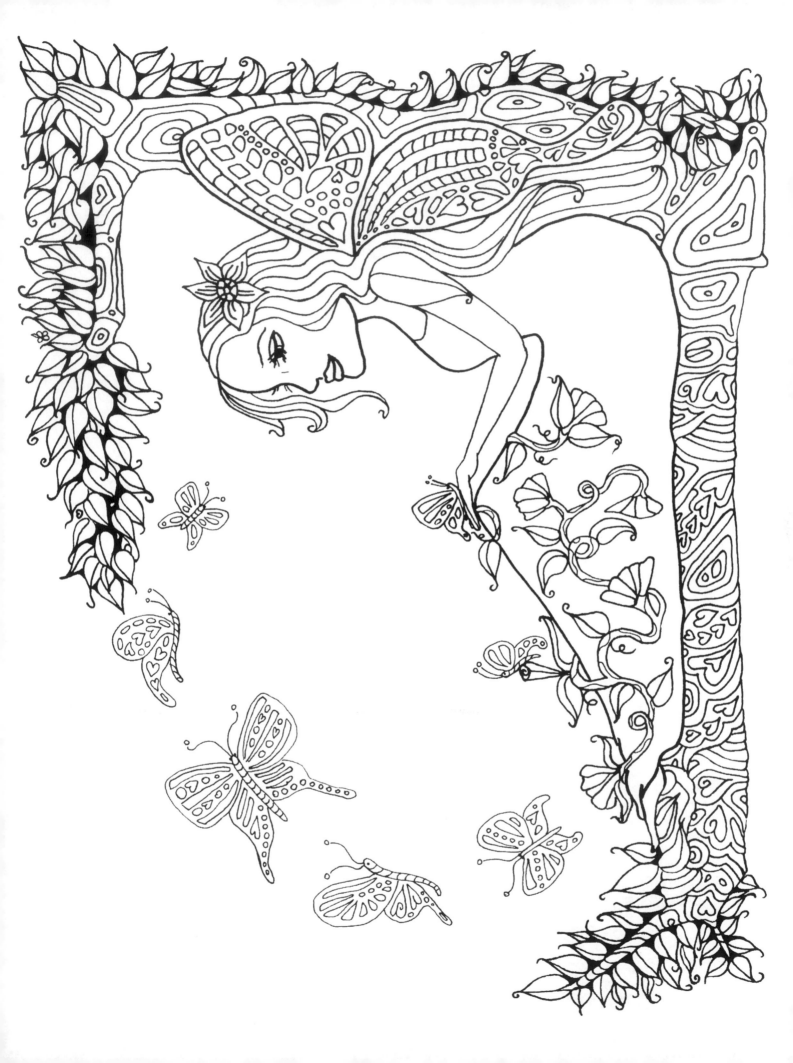

Into a list of wishes that faeries grant true.

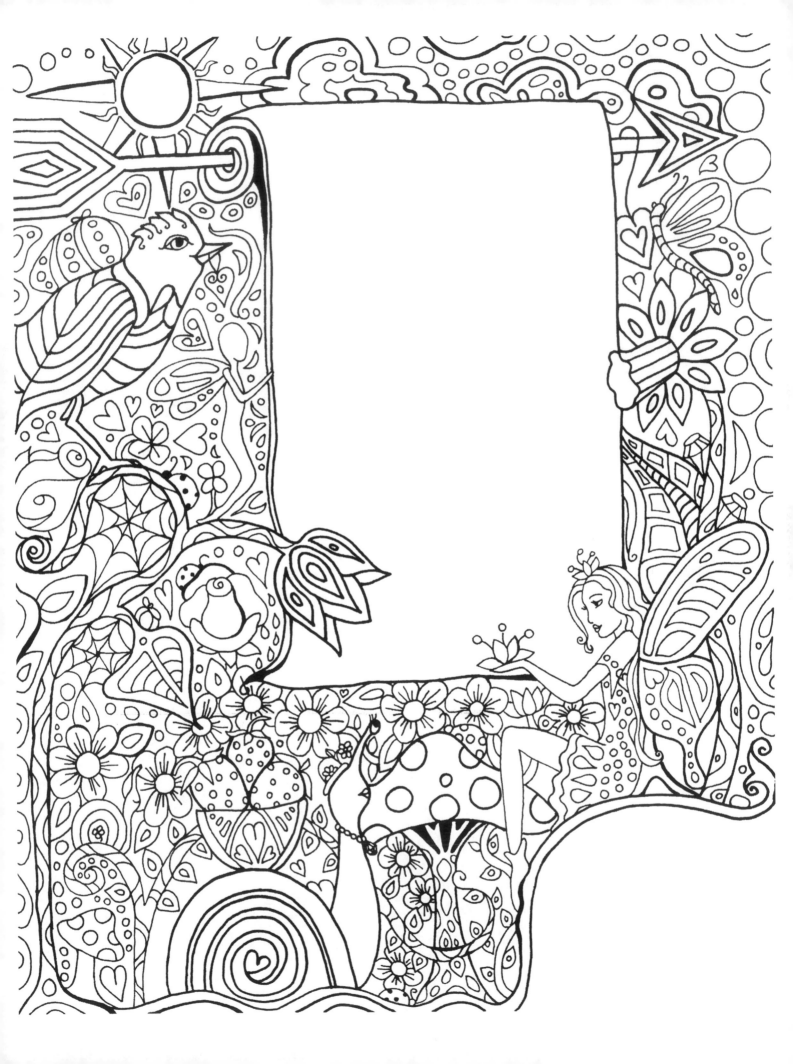

Faery Blessings:

This project was inspired by our many faery blessings in Max, Esther, Estelle, Doug, Norbert, Bernard and Dagobert. The creation of this work coincided with our fight to save a magnificent centennial Deodar Cedar which sadly was felled. Lady Cedar will forever live on in the bend of the branches within and the sway of the faery hearts.

I send much heartfelt gratitude to all who encouraged me to create this book as a small respite from my novels, The Curious Ways of the Winships. A quick trip into the land of faeries is always a good idea to come back to the world refreshed! Many thanks to Sandra Dillon Clare, Wendy Moss and Carla Haddow for their watchful eyes and dragonfly support. Also to my most lovely Lynda Sajovic (Granny Goodwitch), my very own Faery Godmother! Most of all, to my wonderful husband for his computer alchemy in transforming my hand drawn lines into this book combined with all his constant love and encouragement.

This book is dedicated to our little star who left us too soon.

Faery Forest Song

Step into the forest, leave your worries behind
With a compass to guide each dragonfly line.
A fortune is hidden at the bottom of a cup;
Let the owls lead your journey of abundant good luck.
So drift on the leaves as the bats swish aside,
Lost treasures and wishes a dragon might hide.
Peek into the trees and under the berries,
That's where you'll find the wiliest faeries.
Flora and Fauna have gathered their friends
Of wing and root on your path they wend.
With feathers to offer and lights held high,
A treehouse for shelter when moonlight is nigh.
Rest with the bears and share bee dryad dreams
While the Green Man stands watchful of impish night schemes.
The frog chorus sings to their dragonfly love
A lullaby whispered from the stars above
Of diamonds tucked gently in summer rose wild
That awaken in Spring to bloom a faery child.
In the Faery Forest, celebration is the key
To the lifting of spirits by hummingbird and bee.
For in the imagination, hope butterflies brew
Into a list of wishes that faeries grant true.

Made in the USA
Middletown, DE
20 November 2015